Step-by-Step

Handmade Cards

Tamsin Carter

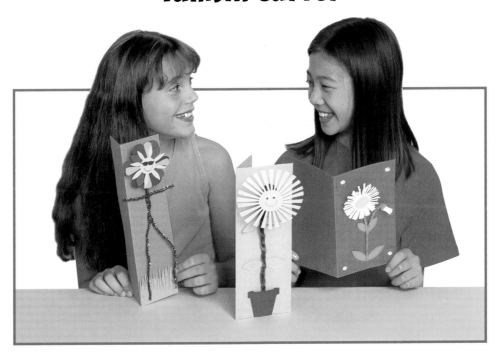

Search Press

First published in Great Britain 2002

Search Press Limited
Wellwood, North Farm Road,
Tunbridge Wells, Kent TN2 3DR

Reprinted 2003, 2004, 2005

ISBN 0 85532 981 5

Suppliers
If you have difficulty in obtaining any of the materials and
equipment mentioned in this book, then please visit the
Search Press website for details of suppliers:
www.searchpress.com

Alternatively, you can write to the Publishers at the
address above, for a current list of stockists, which
includes firms who operate a mail-order service.

Acknowledgements
The Publishers would like to thank Mary Evans Picture
Library for permission to reproduce the photograph on
page 5.

Printed in China by WKT Company Ltd

**This book is dedicated to Steve Carter,
who makes life better than I
ever dreamed.**

*A big thank you to Margaret Smith of
Kuretake UK Ltd for supplying the ZIG pens used
in this book and to G.F. Smith & Son Ltd for their
fabulous range of paper and card.*

*Many thanks also to all my friends at
Search Press, especially Martin and Roz for
giving me this opportunity, Sophie for her
patience and Juan, Dave, Lotti and Inger for all
their hard work and encouragement.*

*I would also like to say a special thank you
to my family, my husband Steve and my
friend Chantal for their support and advice.*

*The Publishers would like to say a huge
thank you to Jessika Kwan, Ellie Hayward,
Stephen Fay, Christopher Owens,
Matthew Knight, Lucia Brisefer,
Amy Weller, Lydia Rawley and Mahbub Ali.*

*Finally, special thanks to Southborough
Primary School, Tunbridge Wells.*

When this sign is used in the
book, it means that adult
supervision is needed.

REMEMBER!
Ask an adult to help you
when you see this sign.

Contents

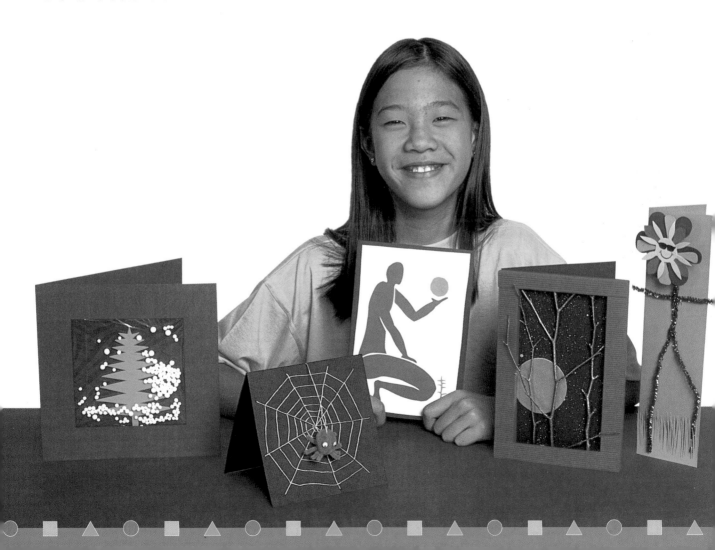

Introduction

Commercial greetings cards are sent for all sorts of reasons: to wish someone a happy birthday, or good luck; to celebrate a festival such as Christmas or New Year; to say thank you, congratulations, or just hello. A greetings card tells someone that you are thinking of them and that you care, and it gives them a picture to display in their home. Just think how much more special a handmade card is, because you have created it yourself and chosen the message personally.

People all over the world have been sending each other hand-decorated messages and cards for hundreds of years, probably since paper became widely available. The oldest known Valentine's card was made in the 1400s and is in the British Museum. Printed cards came later, in the nineteenth century, and were mainly for celebrating holidays or religious festivals.

In this book I show you how to make a variety of different cards using a range of materials including felt, pipe cleaners, beads and even wobbly plastic eyes! Do not worry if you think you cannot draw very well, as there are patterns in the back of the book to help you. I have also included a section on page 28 which shows you easy methods of transferring designs and scoring and folding card. There are lots of fun techniques to try like paint spattering, sewing and collage.

Inspiration can come from all sorts of sources. I usually think of the person I am making the card for, and that gets me started. In this book there are cards inspired by space, nature, musical instruments, dinosaurs, sport, famous artists and ancient wonders. Once you have chosen your subject, you can investigate it further by searching for information in libraries, galleries and museums and on the internet.

Nature is a very good place to find inspiration. You can collect leaves, sticks and flowers to make a collage, or look at the weather and the amazing effects it has on our world. Sometimes the materials themselves can be inspiring: just laying them out in front of you can be enough to trigger an idea and get you started.

Most importantly remember there are no rules; the more you experiment and dare to try something new, the more wonderful your cards will be. A card can be simple or complicated, take an hour to make or just five minutes. A greetings card is very special, it is a gift and a message all in one. Enjoy making them and people will enjoy receiving them.

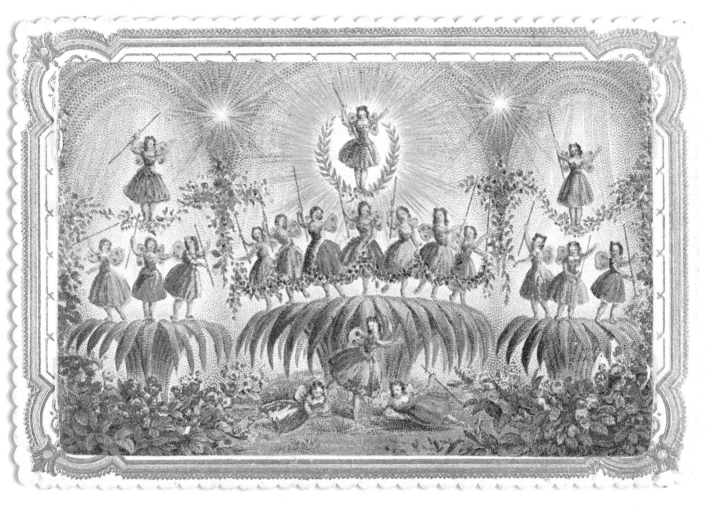

*Greetings cards first became really
popular in Victorian times. This
beautifully painted nineteenth
century Christmas card shows the
ornate and detailed style typical of
the Victorians.*

Materials

The items pictured here are the basic materials that you will need to make the projects in this book. Cards are not expensive to make and you can find a lot of the items shown here at home. Start collecting bits of coloured paper and card, pieces of string and ribbon, beads, buttons, pictures from magazines and even old greetings cards. You can cut these up and recycle them to create your own original designs. Soon you will have a box of treasures to dip into whenever you are feeling creative.

Note Remember to cover your work surface with newspaper or scrap paper before using paints or glue.

Coloured **pipe cleaners** are great fun and can be bent into almost any shape.

Pencils are used for drawing and to transfer designs. A **ballpoint pen** that has run out of ink is used to score card. **Compasses** are used to draw circles and to pierce holes.

A clear **sandwich bag** is used to create a window for the Winter Window card on page 26.

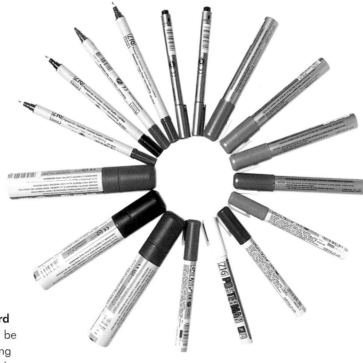

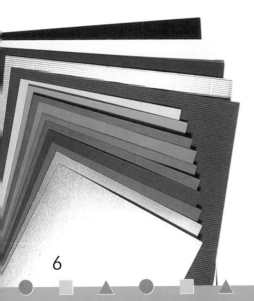

All sorts of **card** and **paper** can be used for making handmade cards. Coloured card is ideal and **corrugated** and **metallic card** can be very effective.

Coloured **pens** are used to draw and colour in designs. **Paint pens** and **metallic pens** are great because they show up on most coloured backgrounds. You can also use **felt-tipped pens**. A **thin black pen** is used to outline designs.

It is safest to use a **blunt-ended needle** like a tapestry needle for sewing.

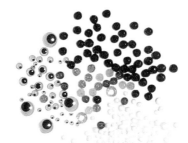

Plastic eyes create lively characters and add movement to cards. **Beads** are used for decoration and **polystyrene balls** are excellent for creating snow.

Cutting your designs out of **high-density foam** gives them depth.

Pencil lines are rubbed out with an **eraser**. A **ruler** is used for measuring and to draw and score straight lines.

Fantastic paint effects can be created with an old **toothbrush** and a **sponge**.

The **paints** used in this book are water-based. Acrylics, gouache or poster paints are best.

Clear **sticky tape** holds sandwich bags and thread in place. **Masking tape** is used to secure a design when transferring it.

Fabrics such as **felt** are great for adding texture. **Scissors** are used for cutting card, thread, fabric and high-density foam. Use an old pair for cutting sandpaper.

Place **thick corrugated cardboard** under your card when piercing holes. **Fine sandpaper** can be used to add texture.

Coloured and metallic **thread** is used for sewing and beading.

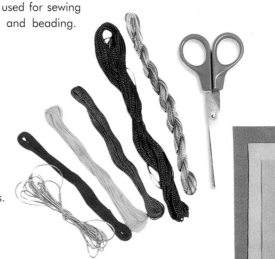

A **glue stick** is perfect for sticking paper and card. **Strong, clear glue** is used to stick on fabric and decorations.

Nazca Birds

In the 1930s, pilots were flying over the desert in Peru in South America when they saw giant drawings on the ground. There was a monkey the size of a football pitch, a lizard twice that length, a spider, fish, birds and insects. It is thought that they were made by the Nazca Indians around two thousand years ago, but nobody knows why. Have a look at them in a library or on the internet and try to imagine why they were made and how. This card is inspired by one of the Nazca drawings, of a large bird called a condor.

YOU WILL NEED
Fine sandpaper
Corrugated card
Empty ballpoint pen
Scissors • Ruler
Strong, clear glue
Paper • Glue stick

Ask an adult to help you to photocopy the design.

2 Photocopy the design on page 30. Cut round it roughly and stick it on to the folded sandpaper with a glue stick. Make sure that the dotted line that runs down one side of the pattern is up against the outer folds. Don't worry if the bird's wings overlap the edge.

1 Fold a sheet of A4 fine sandpaper in half with the sand on the outside. Then fold the top layer in half again, back towards the centre fold. Turn the sandpaper over and fold the top layer in half as before so that you have four equal layers.

3 Carefully cut out the bird shape. Make sure you do not cut off the ends of the feathers that have dotted lines. They should extend to meet the fold.

4 Open out the sandpaper to reveal two condors joined at the wings. Peel off the photocopied pattern. Do not worry if some parts will not peel off – they will not show.

5

Score and fold a piece of A3 corrugated card in half widthways to make a card (see page 28).

6 Stick the condors on to the card with strong, clear glue.

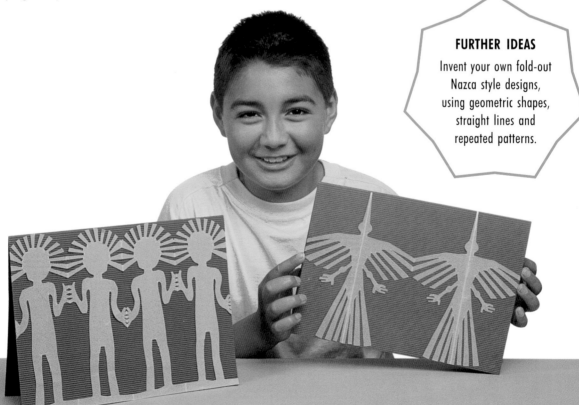

FURTHER IDEAS

Invent your own fold-out Nazca style designs, using geometric shapes, straight lines and repeated patterns.

Fantasy Planets

Space ... the final frontier! What is out there? We know about the planets in our own solar system, but we cannot be sure about what lies beyond. Many people are fascinated by space and all the unanswered questions we have about the universe. With space, you can let your imagination run wild! In this project, spattering white paint on black card makes the perfect starry background for your own fantasy solar system. You can create all kinds of weird and wonderful planets using paint techniques and metallic pens.

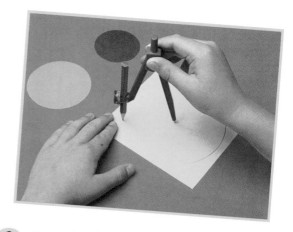

1 Score and fold a large piece of black card in half. Dip the end of a toothbrush in some white paint and slowly run your finger over the bristles so the paint spatters onto the card. Allow to dry. You can spatter on a second colour if you like.

Note Practise spattering or sponging on scrap paper first, and always cover your work surface.

2 To make the planets, use compasses to draw four different sized circles on coloured card. Cut them out.

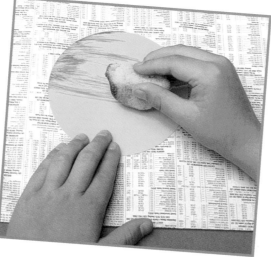

3 Put a circle on some newspaper. Dip a sponge in paint and lightly stroke the colour a little way across from one side. Stroking in a slight curve will make the planet look three-dimensional.

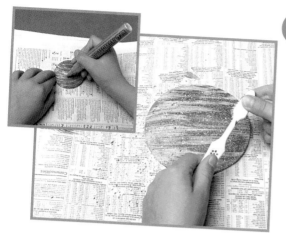

4

Sponge another colour across from the other side and then spatter more colours over the top with the toothbrush. Experiment with sponging, spattering and using metallic pens to decorate the other planets. Leave to dry.

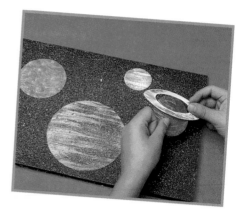

5

Using the pattern on page 29 as a guide, draw a planet ring on card. Make sure it will fit over one of your planets. Then cut it out and lightly sponge some paint across it. Leave it to dry.

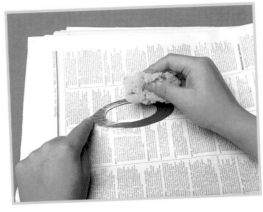

6

Slip the ring over a planet. Move the planets around on your space background until you are happy with the picture. Then stick them all in place with glue.

FURTHER IDEAS
Add aliens, rockets, meteors or space ships to your fantasy solar system.

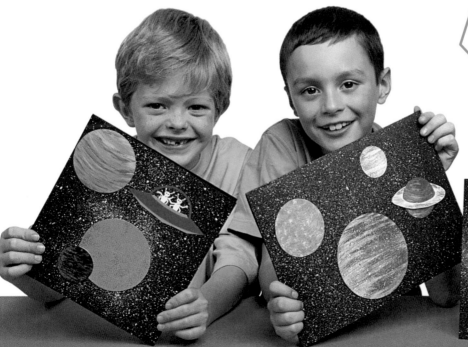

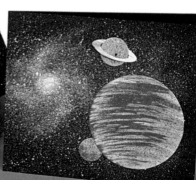

Matisse Collage

Henri Matisse was a famous artist. He was influenced by many different styles. Once when Matisse was ill, he found it difficult to paint, so he made pictures by cutting shapes out of paper and sticking them down to make a collage. 'I am drawing directly in colour,' he said.

In this project I show you how to make a collage inspired by Matisse. There is a pattern on page 30 to help you, but if you feel confident, you could try cutting out your own picture freehand as Matisse did.

YOU WILL NEED

Thin card • Thick card
Compasses • Scissors
Empty ballpoint pen • Ruler
Glue stick • Pencil • Paper
Masking tape

1 Transfer the pattern on page 30 on to thin card, or draw it freehand if you prefer.

2 On a different coloured piece of card, draw or transfer the plant design. Then, using compasses, draw a circle roughly 25mm (1in) across.

3 Cut out all of the shapes using scissors.

Take an A5 piece of thin card and trim 5–10mm (¼in) off each side. Try to leave an uneven edge as you cut.

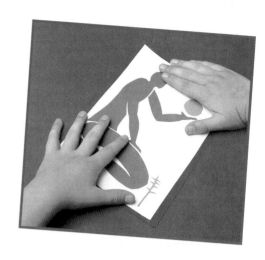

5

Arrange the pieces on the card, leaving small gaps in the figure as shown. Glue them in place with a glue stick.

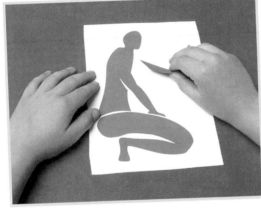

6 Score and fold a piece of A4 card in half and stick the finished collage on to the front.

FURTHER IDEAS
Cut out the shapes for figures, animals or plants, to make your own original collages.

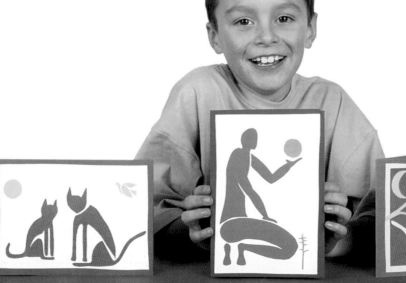

It's a Goal!

Soccer is a brilliant game to play and to watch. Its history dates as far back as the ancient Chinese, Greek, Mayan and Egyptian societies. Modern football developed from games played in England in the nineteenth century. In 1863 these games were separated into rugby football, which is where American football comes from, and Association football, or soccer. You can make this soccer goal card by sewing the net with coloured thread, attaching the goal posts and finally putting the ball in the net – one-nil!

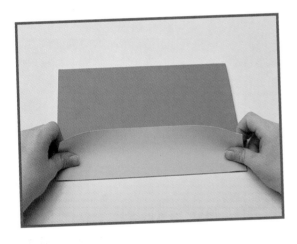

1 Score and fold a piece of thick A4 card in half. Stick a strip of green paper across the bottom.

2 Photocopy the dot pattern on page 31 and secure it to the front of the card with masking tape. Open the card and lay the front over a piece of thick corrugated cardboard to protect your work surface. Using the point of your compasses, pierce holes through the dots on the pattern. Then remove the pattern.

> **!** Ask an adult to help you to photocopy the design.

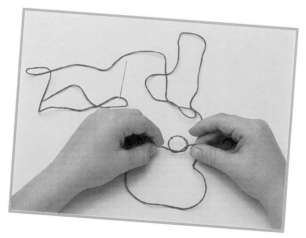
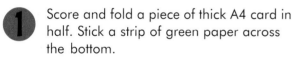

3 Thread one end of a long piece of coloured thread through the eye of a blunt-ended needle. Tie a large knot in the other end.

4

Push the needle up through the hole in the bottom left-hand corner and down through the hole in the top left-hand corner. Do the same for the next holes and continue until all the vertical lines are sewn.

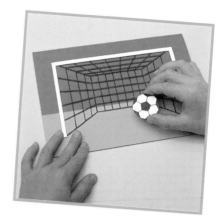

5

Now sew all the other lines of the net, as shown. You will use some holes more than once. If you run out of thread, tie a knot and thread your needle again.

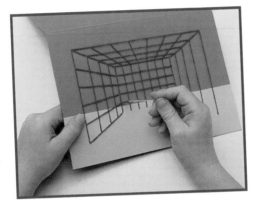

6 Transfer the goal posts and the football design on page 31 on to white card and cut them out. Colour the football with a black pen as shown. Use strong, clear glue to stick the goal posts and ball on to the card.

FURTHER IDEAS
Sew a basketball hoop, tennis racket, spider's web or even somebody's name to make an unusual card.

Spooky Wood

Woods can be very spooky at night. It is easy to imagine pairs of eyes peeping out from the dark. Woods and forests are often used to conjure up a spooky atmosphere in paintings, stories, poems and films. Collect interesting looking sticks and twigs to make the trees in this spooky wood card. Imagine the different creatures that live in the wood as you stick on their eyes. You could even write a spooky poem in the card.

YOU WILL NEED

Bright corrugated card • Thick card
Empty ballpoint pen • Ruler
Scissors • Plastic eyes
Masking tape • Pencil • Paper
Sticks • Strong, clear glue
Black felt

1 Enlarge the design on page 31 on a photocopier and transfer it on to the back of a piece of bright corrugated card. Enlarge the design by 141% to fit on to a sheet of A4, or by 200%, to fit on to a sheet of A3. Cut it out and score and fold along the dotted lines.

2 Fold up the left-hand side of the corrugated card to make a rectangular tube. Squeeze a line of strong, clear glue on to the corrugated side of the end tab and stick it in place. Do the same on the right, but leave the top and bottom open.

! Ask an adult to help you to photocopy the design.

3 Measure the flat area left in the middle. Cut out a piece of black felt the same size. Stick it on with strong, clear glue.

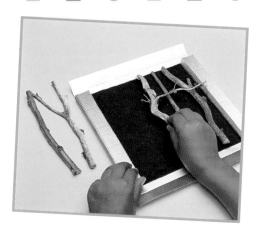

4 Trim the sticks so they fit roughly inside the flat area. Then arrange them on top of the felt to look like a wood.

Ask an adult to help you to cut the sticks.

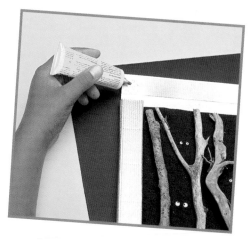

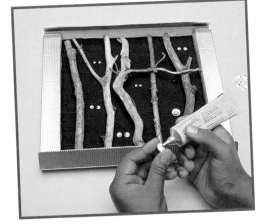

5 When you are happy with the picture, glue down the sticks with strong, clear glue. Then stick pairs of plastic eyes in between the sticks. Leave to dry.

6 Finish the frame by gluing the corners of the top and bottom flaps and sticking them down. Finally stick the finished frame on to a piece of folded card.

FURTHER IDEAS

Spray sticks with snow spray or silver paint and add a silvery moon to make a winter scene.

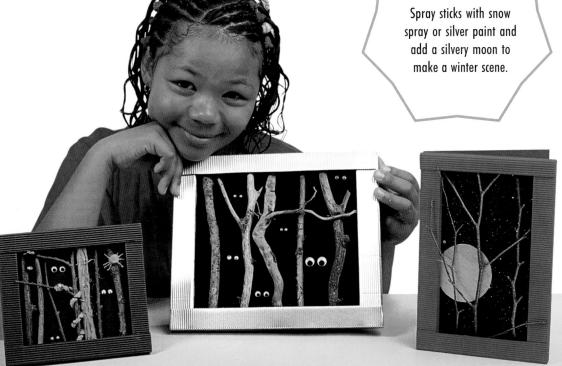

Funky Fish

Fish are very beautiful. It is amazing how many different shapes and colours there are. We have only explored one hundredth of the seabeds on our planet, so there may be even more weird and wonderful varieties of fish to be discovered in the future. In this project, fish are threaded on to metallic thread with beads, to make a bubbly underwater scene.

YOU WILL NEED
Thick card • Thin card
Coloured paper
Metallic thread • Compasses
Glue stick • Strong, clear glue
Sticky tape • Beads • Plastic eyes
Masking tape • Pencil
Empty ballpoint pen
Scissors

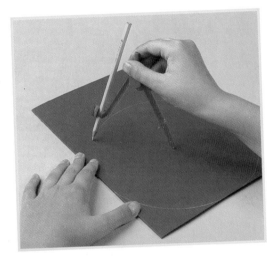

1 Score and fold a large piece of thick card in half. Using compasses and a pencil, draw a circle overlapping the fold and the bottom by about 5mm (¼in) as shown. Cut it out.

2 Open the circular card and draw a square on the front. Cut out the square to make a window. Stick a piece of coloured paper on the inside back of the card (the side you can see through the window) and trim to size.

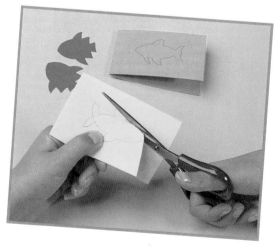

3 Fold three small pieces of thin coloured card in half. Transfer one of the fish designs on page 29 on to each piece of card. Cut out the fish – you will end up with two of each design.

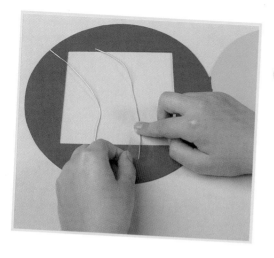

4

Lay two pieces of metallic thread over the window on the inside of the card. Secure them at the bottom with sticky tape.

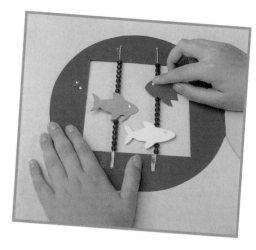

5

Thread some beads on to the first piece of metallic thread. Then take a pair of fish and put glue on one of them. Stick the fish together, sandwiching the thread between them as shown.

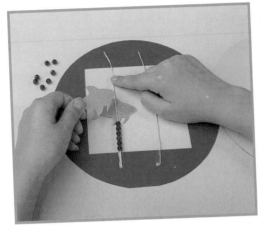

6

Thread on more beads and secure the top of the thread with sticky tape. Do the same on the other thread, using more beads and the other two fish. Finally stick plastic eyes on both sides of the fish using strong, clear glue.

FURTHER IDEAS

Make a card with a different shaped window. Add other sea creatures — an octopus, seahorse or dolphin.

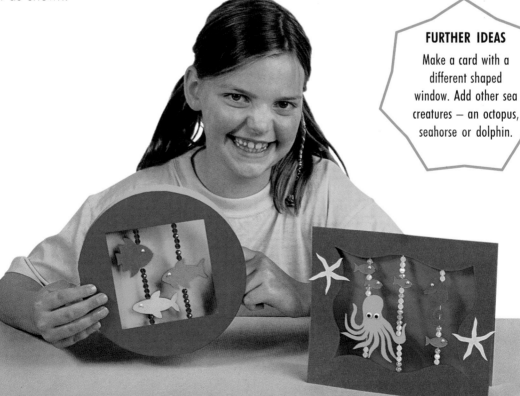

Smiling Sunflower

Flowers are often used to cheer people up, and for special occasions like Mother's day and Valentine's day. Different flowers can mean different things. Red flowers are usually for love – roses, carnations and tulips. White flowers such as daisies and lilies represent innocence and purity. Pansies and poppies are for remembrance, sweet peas for goodbyes, and forget-me-nots speak for themselves! Sunflowers turn their heads to follow the sun across the sky. This one has a lovely smile and a stem made from flexible pipe cleaners, so that its head bobs cheerfully when it moves.

YOU WILL NEED
Card • Pipe cleaners
Scissors • Ruler • Pen
Plastic eyes • Pencil
Masking tape • Paper
Compasses • Eraser • Felt
Empty ballpoint pen
Strong, clear glue

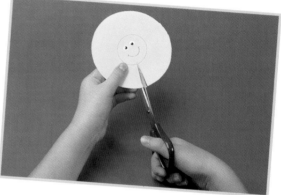

2 Cut a slit from the edge up to the small circle. Then cut a second slit next to it. Continue all of the way around the face. Carefully erase the pencil circle.

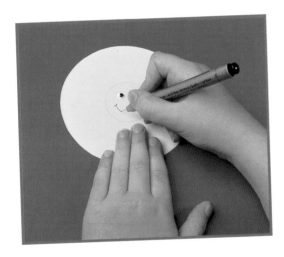

1 Use compasses and a pencil to draw a large circle on some yellow card, then cut it out. Draw a smaller circle in the middle for the sunflower's face. Stick on plastic eyes using strong, clear glue, and draw on a smile.

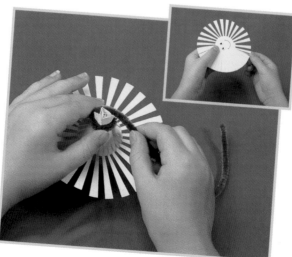

3 Fold every other petal away from you until there is a space between each one. Then hold all the folded petals together and wrap the end of a pipe cleaner round them until they are secure. The rest of this pipe cleaner will be the sunflower's stem.

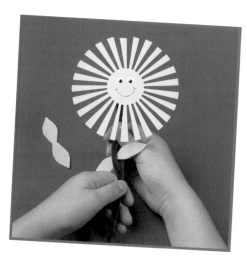

Twist more pipe cleaners around the stem to make it longer and thicker. Cut two sets of leaves out of felt. Push the leaves between the pipe cleaners as shown.

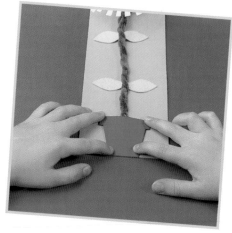

5

Transfer the pattern for the flower pot on page 29 on to card. Cut it out. Score along the dotted lines as shown and fold back the tabs.

6 Score and fold a piece of A4 size card in half lengthways. Glue the bottom half of the flower stem to the card. Put glue on the flower pot tabs and stick the pot over the stem.

FURTHER IDEAS

Create flowers using textured papers or metallic card. Try making several layers of petals.

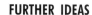

Pop-up Dinosaur

Millions of years ago there were no people, and dinosaurs ruled the earth. We know from digging up their bones what kinds of dinosaurs existed, their sizes and shapes and even what they ate. But we do not know what colours they were. So when you make this pop-up dinosaur card, imagine the colours for yourself and create a prehistoric world of your own. There are patterns for the Tyrannosaurus Rex and the Pteranodon in the back of the book, but you could draw any of your favourite dinosaurs – or even invent your own.

YOU WILL NEED
Thick card • Scissors
Coloured and metallic paint pens
Strong, clear glue • Pencil
Ruler • Masking tape • Paper
Thin black pen • Acrylic paint
Natural sponge

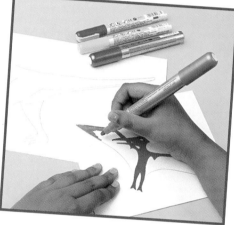

 Transfer the Tyrannosaurus Rex and Pteranodon designs on page 30 on to thick card. Colour them in using paint pens.

Score and fold a large piece of thick card in half. On the top half of the inside, sponge on a strip of paint to suggest a landscape. Leave to dry.

Note Sponging two similar colours on top of each other can make a landscape look more realistic.

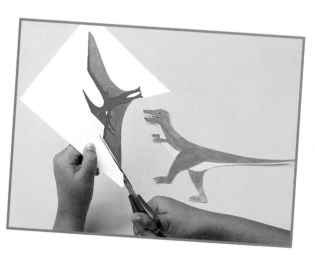

Draw the outlines and the eyes with a thin black pen. Carefully cut the dinosaurs out. If some areas are difficult to cut out, colour them black so that they will not show up.

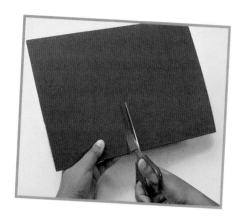

4

Decide where you want your dinosaur to stand, and mark the spot lightly with a pencil. Fold the card inside out. From the fold side, cut two slits up to the mark you have made.

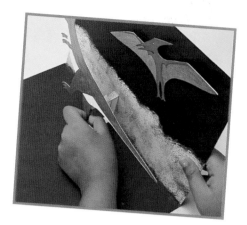

5

Open up the card and press between the cuts to push out a tab. Then close the card again with the tab pushed out and press. This will help to fold the tab in the right position.

6

Open the card and stick the Tyrannosaurus's leg on to the tab with strong, clear glue. Glue the Pteranodon on to the background.

Note To make the Pteranodon stand out from the card, stick a little pad of folded card on the back before gluing it in place.

FURTHER IDEAS
Make pop-up scenery for your dinosaur world: hills, trees, plants, mountains — even a volcano!

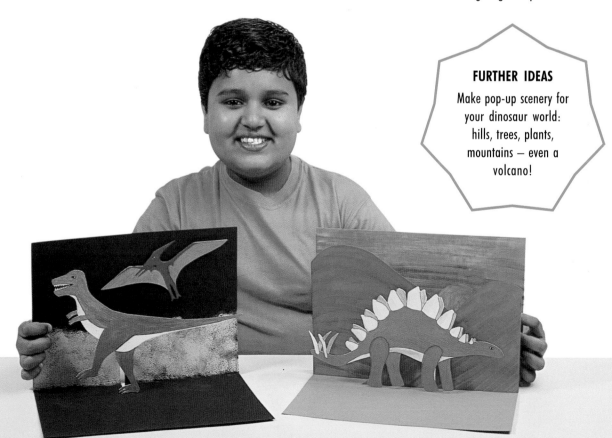

Jazzy Guitar

Guitars are played all over the world to make all kinds of music – from Spanish flamenco and folk music to pop, rock and jazz. They usually have six strings, although there are twelve-string guitars as well. The strings play a different note depending on how taut they are. They can be adjusted to the right pitch using a special tuning key. You can make a card in the shape of a guitar and add strings made from coloured thread.

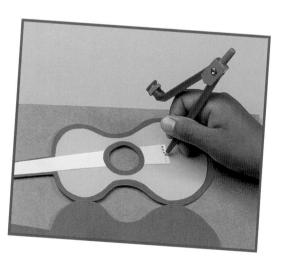

1 Score and fold a piece of thick coloured card in half and transfer the outer guitar design on page 29 on to it. Make sure that the dotted edges marked on the pattern go over the fold line. Cut out the guitar. Open the card and cut out the circle in the middle from the front of the card only.

2 Transfer the inner guitar pattern and the neck and soundboard patterns on to coloured card and cut them out.

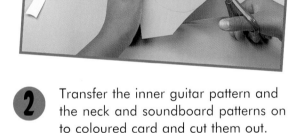

3 Stick the inner guitar, neck and soundboard on to the card. Open up the card, then place it over some thick corrugated cardboard. Pierce the sets of holes on the neck and the soundboard with compasses.

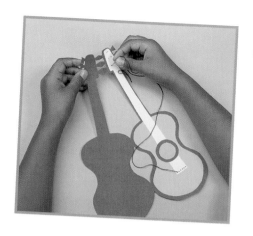

4 Thread one end of a piece of coloured thread through the eye of a blunt-ended needle and tie a knot in the other end. Sew up through the far left hole at the bottom and down through the far left hole at the top.

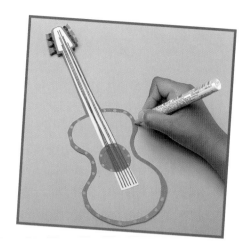

5 Gently pull the thread through until taut. Do not pull it too tight, or the card will bend. Then wrap the end round the bottom left tuning key and tie a knot. Repeat for the other five strings.

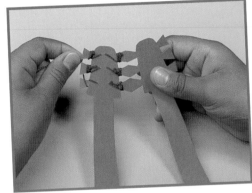

6 Decorate your guitar by drawing big dots around the edge with a paint pen.

Note If you find knotting the thread difficult, you can tape the loose ends at the back.

FURTHER IDEAS
Try making other musical instruments. A banjo has five strings, a double bass has four and a harp has lots and lots.

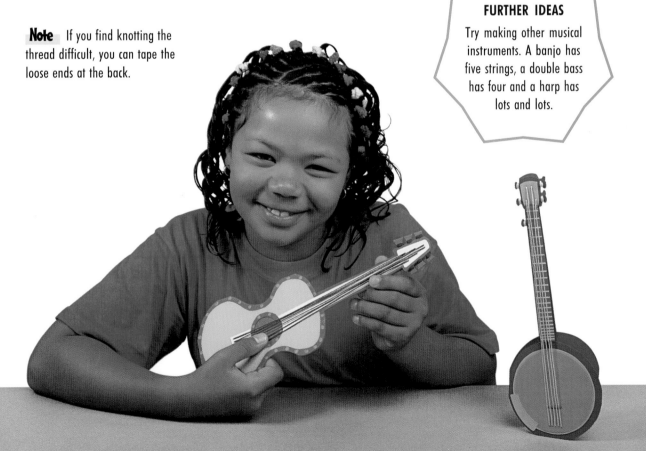

Winter Window

Many cultures around the world have a winter festival. Most of them are linked to the winter solstice. This is the time of the shortest day and the longest night of the year. Some of the festivals celebrated during winter are Christmas, Bodhi Day, Hanukkah and Yule. Winter is a lovely time to gather with family and friends and stay warm by the fire. You can make a winter window card using polystyrene balls for snow and a clear plastic bag such as a sandwich or freezer bag for the window.

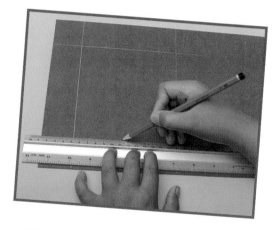

2 On the inside front of the folded card, measure 4cm (1½in) in from each side and draw lines to make a square. Cut out the square.

1

Cut out two pieces of card, one 42cm x 21cm (16½in x 8¼in), and one 21cm (8¼in) square. Fold the big one in half.

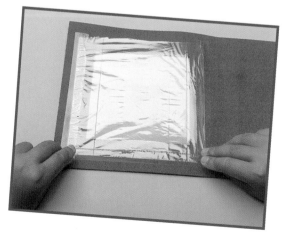

3

Open up the card again and lay a clear sandwich bag over the square. You may need to trim the top of the bag to fit. Use sticky tape to stick it on at the bottom and sides. Do not stretch the bag too tightly, as this will warp the card.

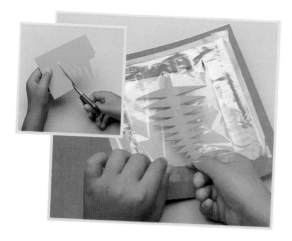

 4

Draw a tree on high-density foam and cut it out. Put a line of glue down the middle of the tree and stick it inside the bag. Make sure the glued side of the tree is uppermost.

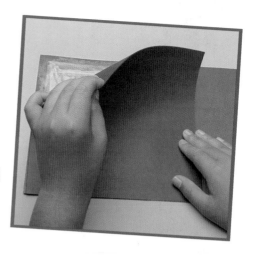

5

Sprinkle some polystyrene balls in to the bag and tape up the top.

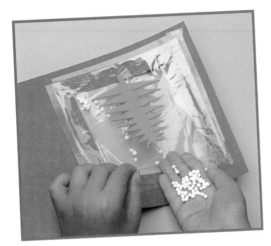

6 Spread strong, clear glue on the inside of the card window frame. Stick the square piece of card on top.

FURTHER IDEAS

You can make all sorts of things to stand in your snow storm — try a snowman, a house, a reindeer or a penguin.

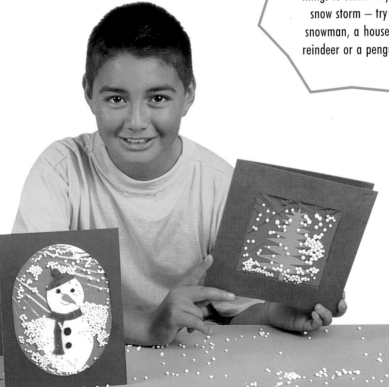

Techniques

⚠ Ask an adult to help you to photocopy the patterns.

Transferring a design

You can photocopy the patterns on pages 29–31 and transfer them on to card using the technique shown below. Use the photocopier to enlarge or reduce the designs if you need to.

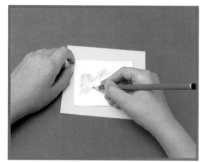 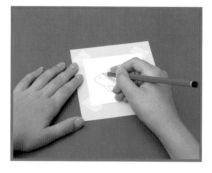

1 Photocopy the design. Turn over the photocopy and scribble over the lines with a soft pencil.

2 Turn the photocopy over and tape it to your card using masking tape. Then go over the lines of the design with a pencil.

3 Peel back the photocopy to reveal the transferred design.

Scoring and folding card

Dotted lines on the patterns need to be scored and folded. You can also use scoring to help make neat cards. Find the centre line by measuring the halfway point and score and fold as shown below.

1 Score a line across the middle of the card with a ballpoint pen that has run out of ink.

2 Fold the card and run the back of your fingernail along the fold to press it down. If the edges are not exactly square, you can trim them with scissors.

Patterns

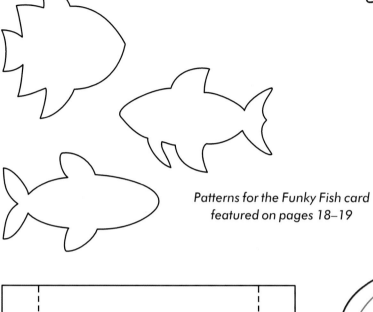

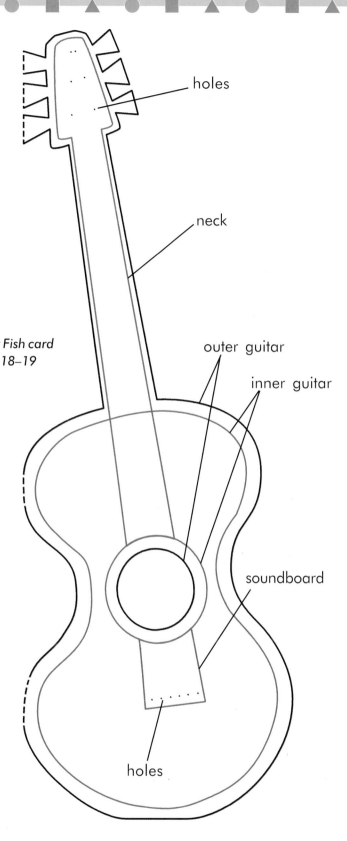

holes

neck

outer guitar

inner guitar

soundboard

holes

Patterns for the Funky Fish card
featured on pages 18–19

Pattern for the flower pot in the Smiling
Sunflower card featured on pages 20–21

Pattern for the planet ring used in the Fantasy
Planets card featured on pages 10–11

Pattern for the Jazzy Guitar card featured
on pages 24–25

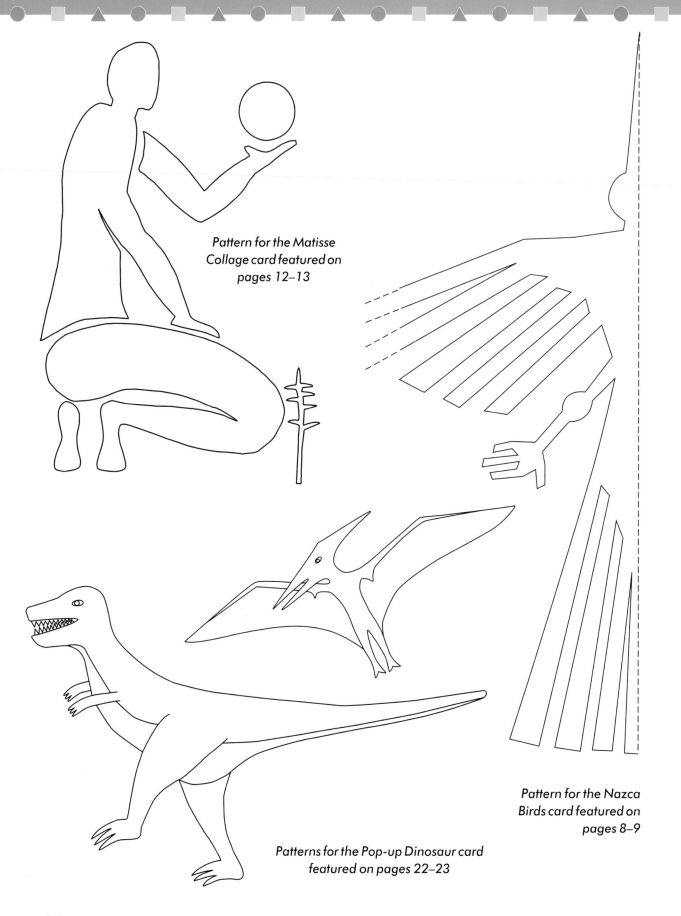

Pattern for the Matisse Collage card featured on pages 12–13

Pattern for the Nazca Birds card featured on pages 8–9

Patterns for the Pop-up Dinosaur card featured on pages 22–23

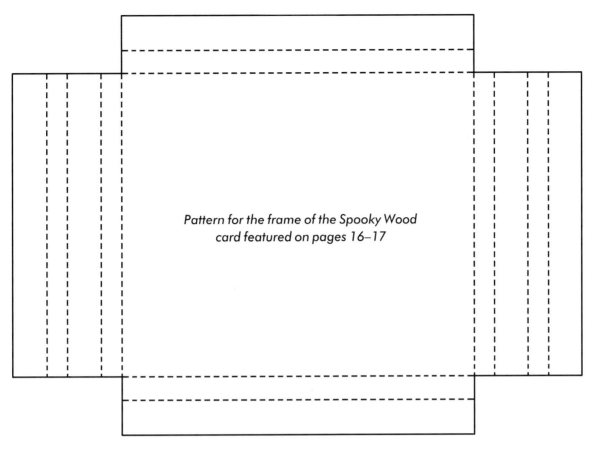

*Pattern for the frame of the Spooky Wood
card featured on pages 16–17*

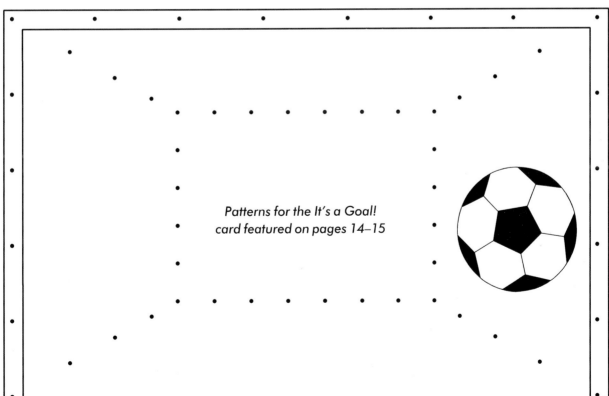

*Patterns for the It's a Goal!
card featured on pages 14–15*

Index

Amazing Science Experiments
Experiments
Playing With Light

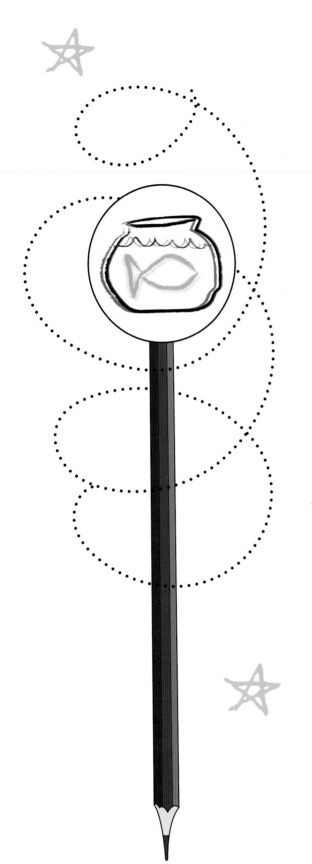

Thanks to the creative team:

Senior Editor: Alice Peebles
Fact checking: Tom Jackson
Design: www.collaborate.agency

First published in Great Britain in 2017
by Hungry Tomato Ltd
PO Box 181
Edenbridge
Kent, TN8 9DP

A CIP catalogue record for this book is
available from the British Library.

ISBN 978-1-910684-95-5

Printed and bound in China

Discover more at
www.hungrytomato.com

Amazing Science Experiments
Playing With Light

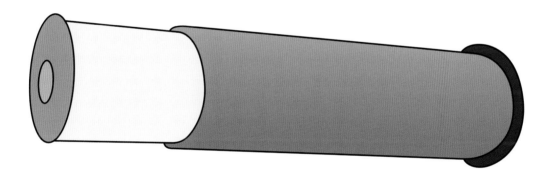

by Rob Ives
Illustrated by Eva Sassin

HUNGRY
TOMATO™

Safety First

Take care and use good sense with these amazing science experiments — some are very simple, while others are trickier. Have fun reading this book and trying the experiments.

Every project includes a list of everything you will need to do it. Most will be stuff that you can find around the house, or is readily available and inexpensive to buy.

We have also included 'Amazing Science', which explains in simple terms the scientific principles involved in each experiment.

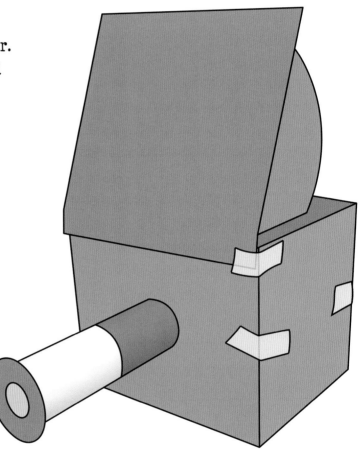

 Watch out for this sign throughout the book and call on adult assistance when cutting materials or doing the experiments.

Contents

Light

Did you know that light is the fastest thing in the universe? In the time it takes you read this sentence, light can travel to the Moon and back, in just 2.6 seconds. All light is tiny packets of energy called photons, shot out by atoms. Everything you see is just countless tiny photons hitting your eyes! Try out these 11 fun projects to find out a few other things about light, too.

You'll see how light is reflected at particular angles when it strikes a mirror. You'll see how light is bent or 'refracted' when it passes through glass or water. You'll also see how lenses in telescopes and microscopes use this refraction to magnify things. And there's much more – even seeing a rainbow tells you light is full of colour!

You will need

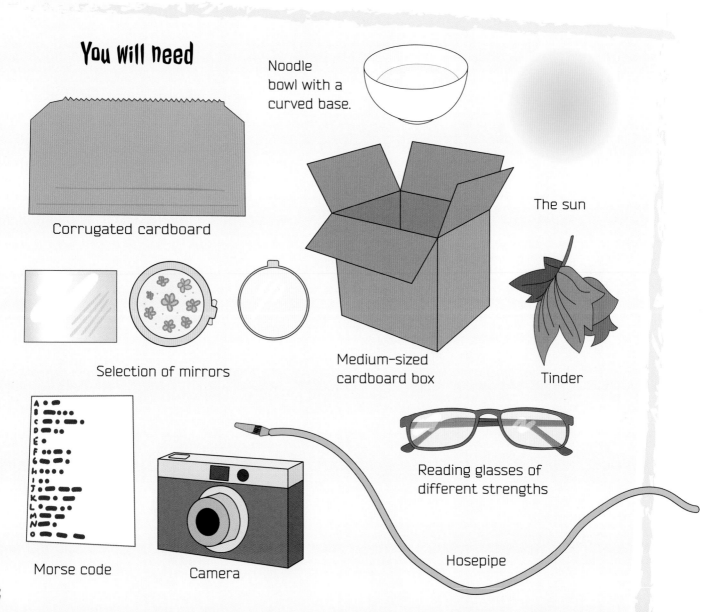

Corrugated cardboard

Noodle bowl with a curved base.

The sun

Selection of mirrors

Medium-sized cardboard box

Tinder

Morse code

Camera

Reading glasses of different strengths

Hosepipe

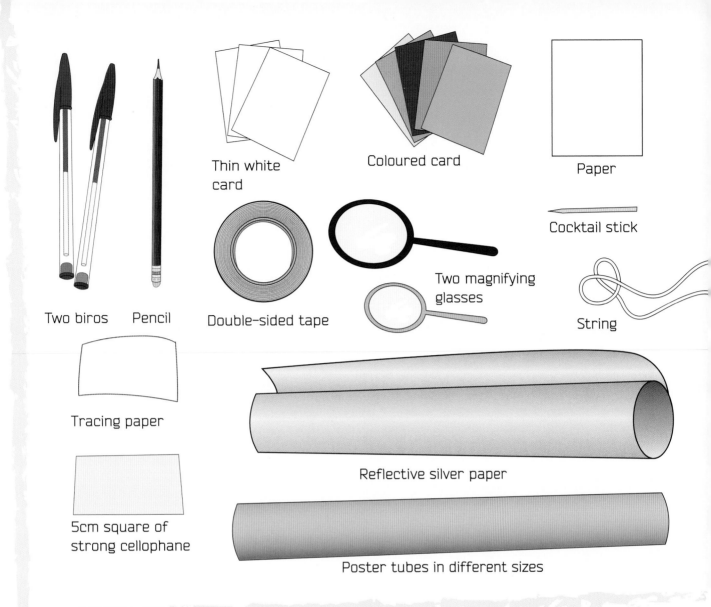

Two biros Pencil

Thin white card

Coloured card

Paper

Double-sided tape

Two magnifying glasses

Cocktail stick

String

Tracing paper

Reflective silver paper

5cm square of strong cellophane

Poster tubes in different sizes

What tools will I need?

Craft knife

Junior hacksaw

Ruler

90mm tape roll

Gaffer tape

Masking tape

Kitchen scissors

PVA glue

Clothes pegs

7

Periscope

A periscope is an optical device for changing your viewpoint. Probably the most famous use for the periscope is in a submarine. It allows the captain to see above the water level without having to break surface and reveal his position. Periscopes also allow small people to see what is going on when they are in the middle of a crowd. They are great for looking over tall walls, and you can even use them for watching the TV from behind the sofa!

You will need

Pencil

Poster tube, 50mm diameter

Double-sided tape

Cheap compact mirror with two 50mm mirrors

Tools you will need
(see page 7)

✶ PVA glue
✶ Junior hacksaw
✶ Masking tape

Offcut of corrugated card

1. Saw the poster tube from the centre of one end at a 45° angle, on both sides.

3. Draw halfway round one end of the tube on corrugated card.

2. Repeat at the other end.

4. Complete the other half of your traced oval shape, then cut it out twice.

8

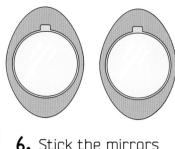

5. Split the mirror in two. Apply double-sided tape to the back of each one.

6. Stick the mirrors to the centre of the card ovals.

7. Glue one mirror card to one end and tape it down with masking tape until the glue dries.

8. Repeat at the other end, making sure the mirror is facing the other way. That's it!

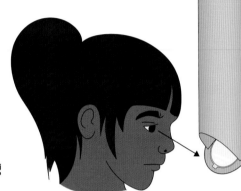

Your periscope is ready to use! Can you see inside that bird's nest in the park?

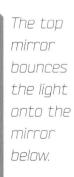

Light enters and hits the top mirror.

The top mirror bounces the light onto the mirror below.

The lower mirror shows the view.

Amazing Science

When light hits a mirror at an angle, it bounces off at the same, but opposite, angle. Another mirror facing the first will show the original view. You can also see round corners with your periscope – just hold it sideways!

Camera Obscura

The camera obscura was the ancestor of the photographic camera. Here, a lens projects a picture upside-down onto a mirror, which flashes a corrected image onto tracing paper. There is also a shade on top to make the image clearer. Long ago, artists used equipment like this to trace over a projected image, as a starting point for their painting.

You will need

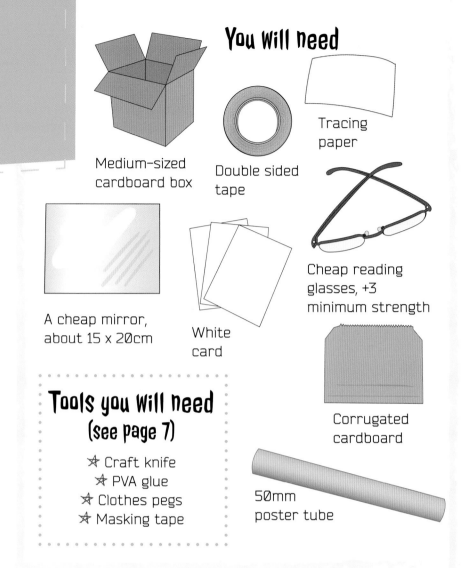

Medium-sized cardboard box

Double sided tape

Tracing paper

A cheap mirror, about 15 x 20cm

White card

Cheap reading glasses, +3 minimum strength

Corrugated cardboard

50mm poster tube

Tools you will need (see page 7)

✯ Craft knife
✯ PVA glue
✯ Clothes pegs
✯ Masking tape

1. Pop out a lens from the glasses. Cut out a doughnut shape from corrugated card, 75mm across with a 40mm hole in the centre.

2. Tape the lens over the hole with masking tape.

3. Cut a 10cm section off the poster tube. Roll up a 20cm length of white card and make a tube that fits inside the poster tube. The poster tube must be able to move back and forward on the white tube, like a telescope.

4. Glue the end of the poster tube to the lens doughnut card.

5. Cut a 10cm square hole in one side of your box with a craft knife.

6. Tape the tracing paper over the hole on the inside with masking tape. Make sure it is taut. This is the screen and will be on the top.

7. Make a shade for the top by cutting three pieces of corrugated card as shown. One is square, the width of the box; and two have a slanted and a curved edge. Allow a 15mm straight margin for each. Glue on the side pieces and hold in place with clothes pegs as it dries. Glue the square piece along its margin to the box to shade the screen.

8. Cut out a piece of corrugated card that fits exactly across the diagonal of the box. Fix the mirror to it with double-sided tape.

9. Cut a hole for the lens tube in the front of the box and fit it in place. Close in the sides and tape them down to finish the camera obscura.

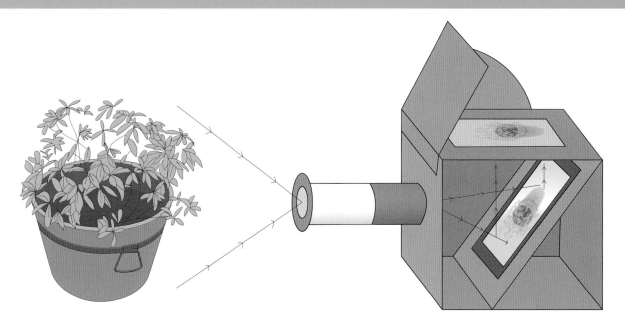

10. Point your lens at a brightly lit scene. Look down at the screen as you move the lens back and forward to focus the image there.

Amazing Science

When a light ray enters glass, it may be bent or 'refracted'. Lenses have curved surfaces that make all the rays bend towards the same point or 'focus'. Here, the lens and the mirror focus the light to project the scene on the tracing paper.

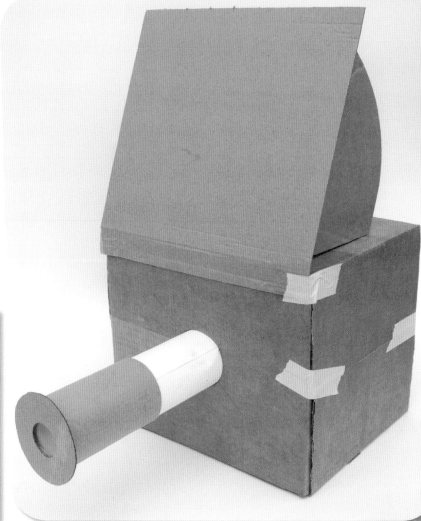

Kaleidoscope

The kaleidoscope is a 19th-century invention that uses a tube of three mirrors to create a colourful moving image. The kaleidoscope is so effective at creating swirling, changing colours that 'kaleidoscopic' now means anything with quickly changing, bright colours.

You Will need

50mm poster tube

Corrugated card

Cheap reading glasses, +2 strength

Reflective silver paper

50mm double-sided tape

Tools you Will need
(see page 7)

✴ Craft knife ✴ PVA glue
✴ Gaffer tape ✴ Kitchen
✴ Ruler scissors

1. Use a craft knife and ruler to cut the tube to roughly 180mm in length. Cut three strips of corrugated card, each 180 x 43mm.

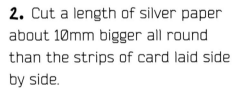

2. Cut a length of silver paper about 10mm bigger all round than the strips of card laid side by side.

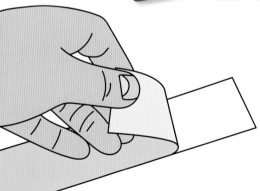

3. Apply 50mm double-sided tape to the back of the card strips and trim it to fit. Peel off the backing.

4. Stick the card strips to the back of the silver paper so that they are touching each other. Trim the excess silver paper from around the edges.

13

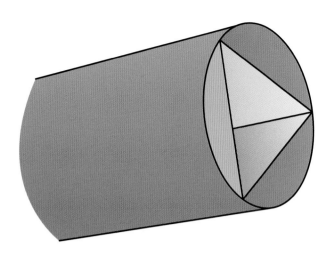

5. Fold along the edges of the card strips and fit the piece into the tube.

6. Pop out one of the lenses from the reading glasses. Cut a circle of card to cover the end of the poster tube and cut a circular hole in its centre to match the width of the lens.

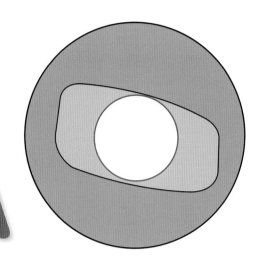

7. Tape the lens in place, making sure not to get tape over the hole.

8. With the lens on the inside, glue the lens holder to the end of the poster tube to complete your kaleidoscope.

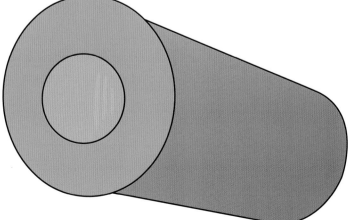

9. Point the open end of the kaleidoscope at colourful objects, such as flowers or bright pictures.

Marvel as the reflected colours swirl around when you move the kaleidoscope!

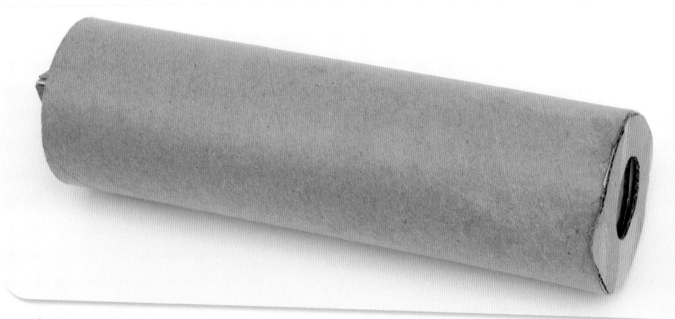

Amazing Science

The kaleidoscope was invented by English scientist Sir David Brewster in 1814. It uses three mirrors set at a slight angle to reflect each other in a perfectly symmetrical (matching) pattern. Colours swirl in different patterns as you view objects through the lens.

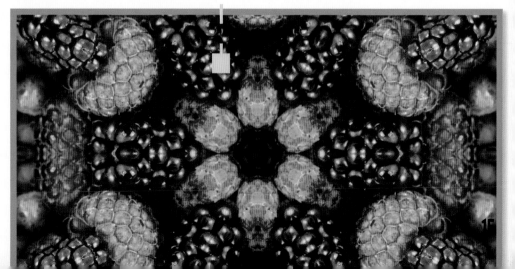

Heliograph

In the past, the heliograph was used to communicate long-distance. By flashing sunlight from one person to another, complicated messages could be sent at the speed of light. There are just a few problems with this: it has to be sunny; you must be able to see the person you are sending a message to; and it is s-l-o-w! But you can send a message several miles and it's difficult for anyone to eavesdrop.

Try it with a friend, using Morse code (below): short flashes for dots and long flashes for dashes.

You will need

The sun

A small pocket mirror each

A copy of the Morse code each

Line up your friend with a 'target', and your signal will travel on to reach them, too.

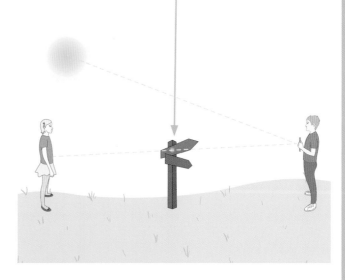

A • ▬	U • • ▬	
B ▬ • • •	V • • • ▬	
C ▬ • ▬ •	W • ▬ ▬	
D ▬ • •	X ▬ • • ▬	
E •	Y ▬ • ▬ ▬	
F • • ▬ •	Z ▬ ▬ • •	
G ▬ ▬ •		
H • • • •		
I • •		
J • ▬ ▬ ▬		
K ▬ • ▬	1 • ▬ ▬ ▬ ▬	
L • ▬ • •	2 • • ▬ ▬ ▬	
M ▬ ▬	3 • • • ▬ ▬	
N ▬ •	4 • • • • ▬	
O ▬ ▬ ▬	5 • • • • •	
P • ▬ ▬ •	6 ▬ • • • •	
Q ▬ ▬ • ▬	7 ▬ ▬ • • •	
R • ▬ •	8 ▬ ▬ ▬ • •	
S • • •	9 ▬ ▬ ▬ ▬ •	
T ▬	0 ▬ ▬ ▬ ▬ ▬	

1. Choose an open space with the sun to one side of you when you face each other. Stand on either side of an object and line up your friend with the object.

2. Reflect the sunlight with your mirror onto the ground near you. You should see a bright spot the same shape as your mirror. Now shine it at the object.

3. Move it up just slightly to flash a beam at your friend. It will reach them because light travels in straight lines.

Ice Lens

Can you start a camp fire using just ice? You can if the sun is shining!

1. When the boiled water is cool, pour it into the bowl to a depth of around 5cm. Freeze it overnight to make your ice lens.

2. Warm the outside of the bowl in warm water and drop the lens into a gloved hand.

3. Arrange your tinder in a safe place outside. Use the ice lens to focus the sun's rays on the tinder until it starts to smoulder. Arrange some small twigs on top and make yourself a small camp fire!

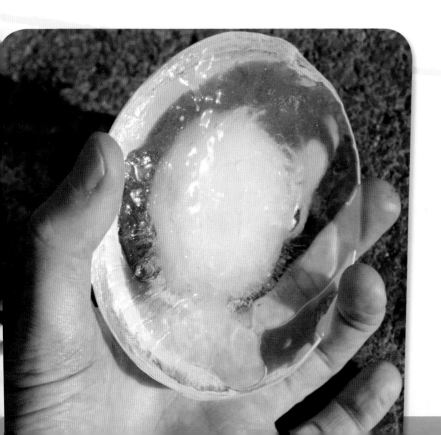

Amazing Science

A convex, or outward-bulging, piece of clear ice acts like a lens, to focus the sun's rays together. The concentration of light can heat tinder enough to start a fire. Be sure to put out your mini campfire properly afterwards!

17

Microscope

Microscopes reveal a hidden world that you can't see with the naked eye. This super-simple microscope lets you magnify 10–20 times — and all it needs is a drop of water! Dutchman Antonie van Leeuwenhoek invented the microscope in the 1660s, and so discovered all kinds of minute things from the hairs on a flea to tiny life forms in pond water.

You Will need

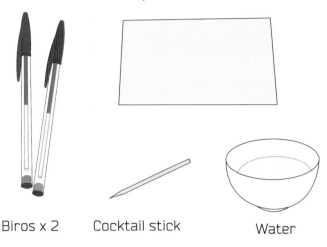

5cm square piece of strong cellophane

Biros x 2 Cocktail stick Water

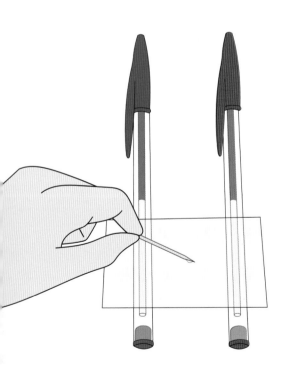

1. Space out two biros roughly 3cm apart. Balance the cellophane on top as shown.

2. Dip the cocktail stick in water and transfer a drop to the middle of the cellophane. Keep adding drops of water until the drop on the cellophane is about 5mm across. That's your microscope complete!

3. You can experiment with different drop sizes. Smaller drops give greater magnification but a narrower field of view. Larger drops give less magnification but a better field of view.

4. Place the object you wish to investigate under the water drop. Look down through the drop to observe the magnified image.

Once you start investigating the microscopic world, there are all sorts of amazing things to see. Try looking at sugar and salt crystals. Can you learn to identify which is which, just by its appearance? See if you can persuade an insect to crawl under your microscope. Don't forget to let it go when you have finished your investigation.

See what microscopic discoveries you can make!

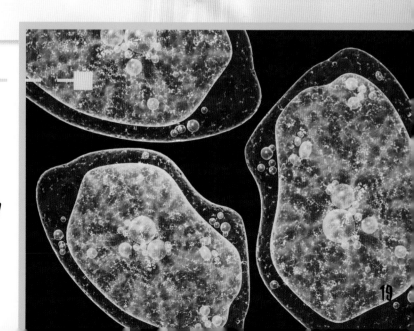

Amazing Science

Van Leeuwenhoek discovered minibeasts such as amoebas (right) with a microscope that was just a tiny bead of glass. Your simple microscope allows you to see tiny things magnified with just a drop of water. The curved surface of the drop acts as the magnification lens.

19

Persistent Pencil

You Will need

Two discs of thin white card, 30mm across

Persistence of vision (see below) is at the heart of many optical effects and illusions. Here, this effect makes two pictures appear as one, merged picture.

Tools you Will need (see page 7)

✴ Epoxy glue

Pencil

1. On one disc draw a small fish. On the second disc draw a fish bowl.

2. Glue the two discs back to back, leaving a channel in the middle.

3. Slot the pencil through the middle of the discs.

4. Spin the discs briskly between the palms of your hands and watch the fish appear inside the fish bowl.

Amazing Science

When we look at something, the picture stays in our eyes for a moment. This is called 'persistence of vision'. Our brains also fill in the gaps when something moves. These two effects make us see a movie as continuous motion — though it is really a series of rapidly changing still pictures.

Hose Rainbow

Conditions need to be just right for a rainbow to form. There must be sunshine as well as rain, and everything has to line up. The sun has to shine from behind you and the rain be in front of you. Then you will see a glorious rainbow!

1. Stand with your back to the sun, set your garden hose to a fine spray and spray it away from yourself. A rainbow will appear in front of you!

2. Try different settings on the hosepipe attachment to see which makes the best rainbow.

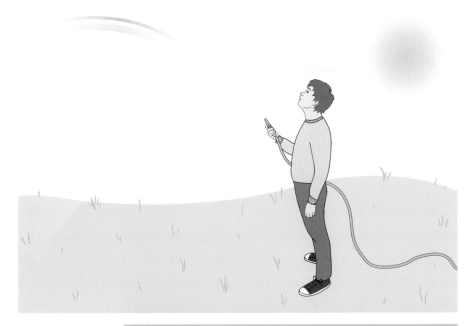

Amazing Science

Rainbows occur when sunlight is reflected within raindrops. The light is split into its colours as it is refracted (bent) by the water. The colours separate because each is bent by a different amount.

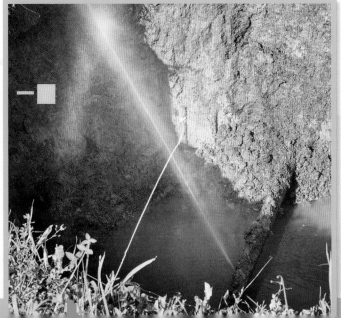

21

Spinner

String

Paper

Corrugated cardboard

This spinner is an experiment in colour mixing! As the disc spins fast, all the colours blur into one, revealing the average colour.

Coloured card

Tools you will need
(see page 7)

* ✷ 90mm tape roll
* ✷ PVA glue
* ✷ Kitchen scissors
* ✷ Pencil

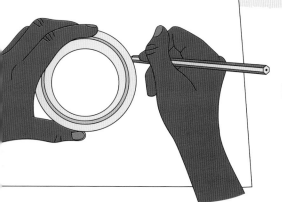

1. Draw round the tape roll on paper. Cut it out, then fold it into six. Cut out one of the six segments. This will be your template.

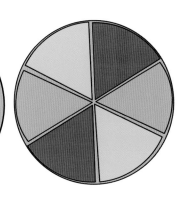

2. Cut out six segments of coloured card using your template as a guide.

3. Cut out a corrugated card disc using the same roll of tape as a template.

4. Glue the six segments on the card as shown.

22

5. Make two holes off-centre on the disc, and thread 75cm of string through. Spin the disc by winding it up, then rhythmically pulling and releasing to speed it up.

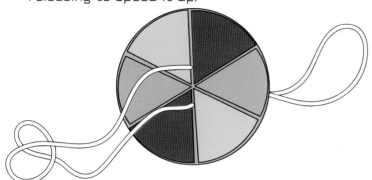

See if you can guess what colour you will see before you start spinning. What happens if you mix yellow and red, black and white, blue and red? Are the colour mixes the same as when you mix paint? What happens if you only add one slice of one colour and five of another? What if you cover the disk in random circles of different colours!?

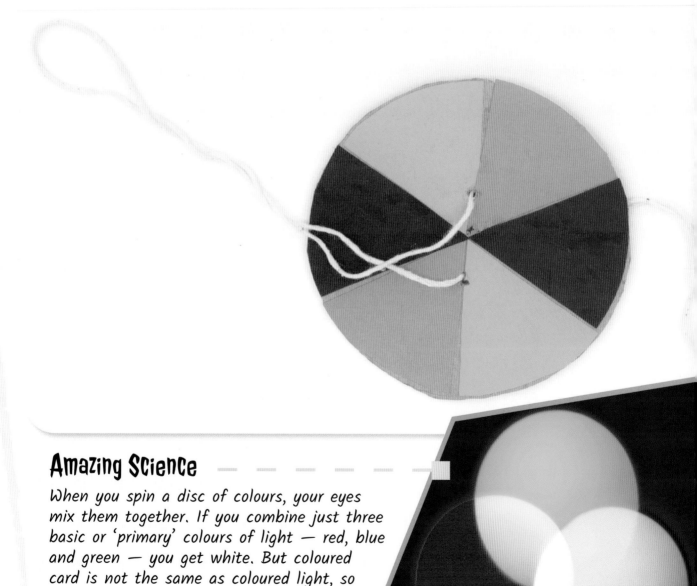

Amazing Science

When you spin a disc of colours, your eyes mix them together. If you combine just three basic or 'primary' colours of light — red, blue and green — you get white. But coloured card is not the same as coloured light, so here you end up with a browny colour!

Stereoscopic Pictures

When you look at an object you get two slightly different views of it, one to each eye. Your brain merges the picture together to reveal it in 3D! You can also fool your brain by recreating two different views in photographs. These paired pictures can be seen in 3D with the viewer from p.26.

You will need

Thin white card

...and a printer

Camera

Tools you will need
(see page 7)
★ PVA glue

1. For your pictures, choose a subject with good front-to-back depth. Complex, intricate objects, such as bushes or trees, also work well. Check that the lighting is constant and the object is stationary.

2. Take a photograph. Move 6–7cm to your right without turning and take another photograph. These will be your stereo pair.

3. Print out both pictures so that they are roughly 55mm wide. This is the best fit for the viewer in the next project.

4. Glue both pictures to a piece of card with a very small gap between them. The first picture goes on the left, the second on the right.

Try other subjects such as still lifes or outdoor plants...

25

StereoViewer

A simple viewer allows you to see the 3D effect of the stereoscopic pictures you made on p.25.

Corrugated card

☆ Craft knife
☆ Gaffer tape
☆ PVA glue
☆ Clothes pegs

Strong reading glasses, +3 strength

1. Carefully pop the lenses out of the reading glasses.

A 140 x 80mm

C 200 x 40mm

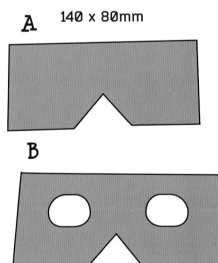

B

2. Cut out the three pieces A, B and C as shown. Cut holes in B slightly smaller than the lenses, with the centres 80mm apart. On C, mark and score tab and centre lines. Make notches and fold along the score lines.

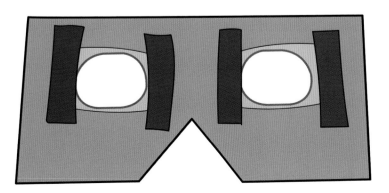

3. Tape the lenses in position with gaffer tape.

26

4. Assemble the three parts, fixing the tabs with PVA glue. Use clothes pegs to hold them together until the glue has dried.

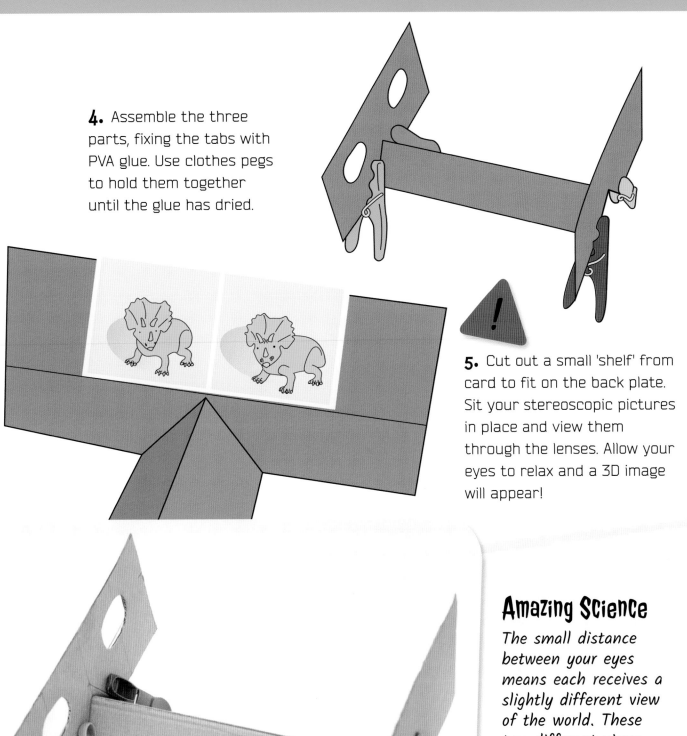

5. Cut out a small 'shelf' from card to fit on the back plate. Sit your stereoscopic pictures in place and view them through the lenses. Allow your eyes to relax and a 3D image will appear!

Amazing Science

The small distance between your eyes means each receives a slightly different view of the world. These two different views are transmitted to the brain, which merges them to give the impression of depth and solidity.

Telescope

Pencil

A single lens can magnify things close by. A telescope allows you to see far away, because it has at least two lenses, or curved mirrors. Dutchman Hans Lippershey, who made magnifiers, is the likely inventor of the telescope, in 1608.

White card Corrugated card

Tools you will need
(see page 7)

✮ PVA glue
✮ Gaffer tape
✮ Ruler
✮ Craft knife

Two magnifying glasses: one with a wide lens (eg 75mm) at 4x magnification; and one with a small lens (eg 30mm) at 20x magnification

A poster tube roughly the same diameter as the large lens

1. Find the focal length of the two lenses. Hold the weaker lens up to focus a clear image from outside onto your wall. Measure the distance from the lens to the wall.

2. Repeat with the more powerful lens. The focal length will be much shorter.

3. Add the two focal lengths together (example above: 16cm + 2cm = 18cm). Your poster tube should be a couple of cm shorter than the combined focal length.

4. Fit the large lens to the end of the poster tube with glue or tape.

5. Roll up a 20cm length of thin white card so that it will just fit inside the tube. Draw round the end on a piece of corrugated card.

6. Cut out the card circle. Cut out a hole in the centre and tape the smaller lens over the hole.

7. Fit the inner tube into the outer tube.

8. Tape or glue the small lens over the end of the inner tube. This tube should be able to move back and forwards in the outer tube. Do this to focus your image. Close objects will need a longer tube, distant objects a shorter tube.

9. Look through your telescope. Notice that the image is inverted! This is always the case with this type of telescope.

Don't look at the sun!

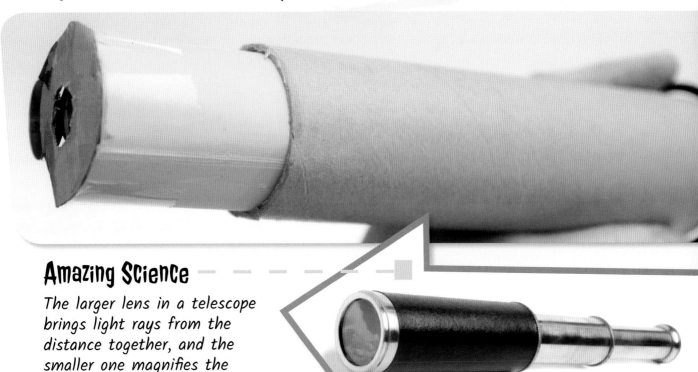

Amazing Science

The larger lens in a telescope brings light rays from the distance together, and the smaller one magnifies the image enough for you to see it.

Glossary

Camera Obscura Named after the Latin for dark (obscura) room (camera), it was just that: a dark room with a small hole in one wall. When light from a scene outside beamed through the hole, it produced an upside-down, mirror image of that scene on the opposite wall. Box-like devices were made that mimicked this effect, with a lens inserted into the hole. Artists used these to help them draw and paint scenes accurately. The camera obscura also developed into the box camera that captured images on photo-sensitive paper.

Convex Curving outwards. (The opposite is concave, or curving inwards.) A convex lens is thicker in the middle than at the edge. Light rays passing through it are brought close together, or converge.

Focus The point were converging light rays meet.

Lens A shaped piece of polished glass or plastic used to bend light rays together and focus them, or disperse them (spread them out).

Persistence of vision The optical illusion where many short flashing images are merged into a single image by the brain.

Photon The basic particle of visible light. Light energy is formed from photons streaming through space at 299, 792 km (186,282 miles) per second.

Refraction The bending of light rays, which happens when they move from air into a transparent substance, such as water or glass.

Stereovision Also known as 3D vision, the impression of looking at something in 3D. Our two eyes each receive a slightly different picture and the brain merges them into a single image that has width, height and depth.

Did You Know?

★ The Nimrud lens is the oldest lens, a 3,000-year-old rock crystal discovered in 1850 in what was then Assyria, now Iraq. It may have been used as a magnifying glass or burning glass for starting fires.

Early art from Nimrud, Assyria

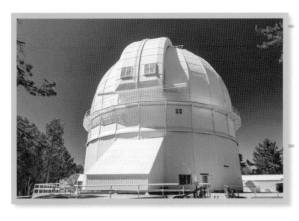

★ The Hooke Telescope on Mount Wilson in California, USA, proved that other galaxies exist and the universe is expanding.

★ The Hubble Space Telescope, launched in 1990, has an 8-ft mirror for collecting available light.

★ The earliest microscopes were called 'flea glasses' because they were used for studying insects. An electron microscope can focus on an object one nanometer (one-billionth of a metre) in size, and magnify it 5,000,000 times.

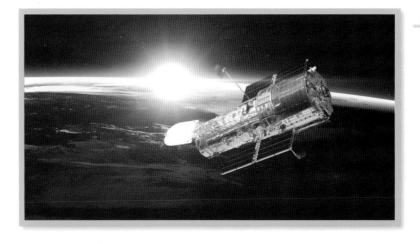

INDEX

The Author

Rob Ives is a former maths and science teacher, now a designer and paper engineer living in Cumbria, UK. He creates science- and project-based children's books, including Paper Models that Rock! and Paper Automata. He specializes in character-based paper animations and all kinds of fun and fascinating science projects, and often visits schools to talk about design technology and demonstrate his models.

The Illustrator

Eva Sassin is a freelance illustrator born in London, UK. She has always loved illustrating, whether it be scary, fun monsters or cute, sparkly fairies. She carries a sketchbook everywhere, but has even drawn on the back of receipts if she's forgotten it! In her free time, she travels around London to visit exhibitions and small cafés where she enjoys sketching up new ideas and characters. She is also a massive film buff!

Picture Credits (abbreviations: t = top; b = bottom; c = centre; l = left; r = right)
© www.shutterstock.com:

9 br, 12 bl, 15 br, 17 br, 19 br, 21 br, 23 br, 29 br, 31 tr, 31 cl, 31 br.